PHOTOGRAPHY AT THE MUSÉE D'ORSAY

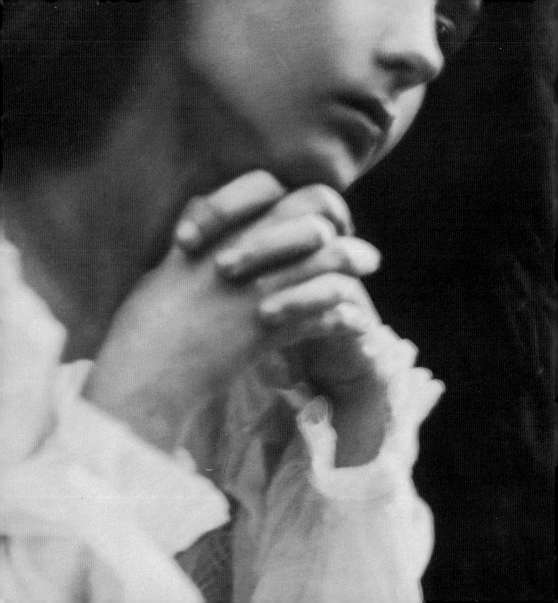

Joëlle Bolloch

The Hand

Musée d'Orsay

5
CONTINENTS

This collection is directed by Serge Lemoine,
Chairman of the Musée d'Orsay.
All works reproduced in this volume belong
to the Musée d'Orsay's collection
and are kept in the museum.

This book has been conceived for the exhibition *La Main*
at Musée d'Orsay, with the support of the Fondation
Bettencourt Schueller, 18th June – 30th September 2007,
curated by Joëlle Bolloch.

Acknowledgements:
Isabelle Gaétan, Christian Garoscio, Fabrice Golec,
Pierre-Yves Laborde, Dominique Lobstein,
Laure de Margerie, Jérôme Picon, Anne Pingeot,
Laurent Stanich, and Gabrielle Baratella, Floriane Herrero,
Marion Kling, Virginie Lagane, Maria Montero,
Anne Schmauch, Lykke Kirkegaard Thomsen

www.musee-orsay.fr
www.fivecontinentseditions.com

© Alfred Stieglitz, Henri Rivière by ADAGP 2007
© Steichen carousel, 2007, cat. 47 and 49
© Aperture Foundation, Inc., Paul Strand Archive, cat. 53
Cat. 16, by courtesy of Derek Tisdall

© Musée d'Orsay, Paris, 2007
© 5 Continents Editions srl, Milan, 2007

ISBN Musée d'Orsay: 978-2-905724-78-6
ISBN 5 Continents Editions 10: 88-7439-431-4
ISBN 5 Continents Editions 13: 978-88-7439-431-9

Cover
Adolphe Bilordeaux
Étude de main en plâtre, 1864

For the Musée d'Orsay

Publication manager
Annie Dufour

Assisted by
Jean-Claude Pierront

Iconography and digitalization
Patrice Schmidt and Alexis Brandt

For 5 Continents Editions

Translation
Isabel Ollivier

Editorial Coordinator
Laura Maggioni

Design
Lara Gariboldi

Layout
Daniela Duminuco

Editing
Andrew Ellis

Colour Separation
Eurofotolit, Cernusco sul Naviglio (Milan), Italy

Printed in June 2007
by Leva Arti Grafiche, Sesto S. Giovanni (Milan), Italy

Printed in Italy

Table of Contents

The Hand 6

Entries 20

Selected Bibliography 30

Plates 32

Joëlle Bolloch

The Hand

Never without the Hands!

"A man of substance seldom has himself painted without his hands, unless it is against his will. For him there is no such thing as a portrait without the hands: it is something incomplete, like a legless cripple. He is preoccupied to the highest degree by the position and expression of the hands," wrote François Victor-Fournel (1829–94) in *Ce qu'on voit dans les rues de Paris* (1858). "One poses with his right hand on his chest; another folds it negligently on his belt, or drops it to his side; yet another will sit with his elbow hooked over the back of his chair, like Schubert in his daughter's copy of *Melodies*." This chronicler of Parisian society life sniped at the poor taste of the middle classes and their fondness for painted portraits, but this was only a roundabout way of approaching the real target of his criticism, namely, the new vogue for photographic portraits. "The worst of all is the daguerreotype. … One chap tinkers with his watch-charms; another plunges a hand into his waistcoat with a thoughtful air copied from our great parliamentary orators; yet another invites the admiration of the crowd, a book in his left hand and a pen in his right." Victor-Fournel used the term daguerreotype in the broader sense of photography, as by the time his pamphlet was published, the daguerreotype had become only one of the many new techniques of reproduction.

The early photographers had no other reference but painted portraits, and they used the same codes of representation. Hands have always had a primordial place in the history of portraiture, functioning as psychological, dramatic, or expressive indicators since the Renaissance. Although they are not as difficult to render as facial features, which must convey both a likeness and expression, hands are complicated for the artist, as is evidenced by the large quantity of preparatory sketches and drawings. When billing his portraits, Francisco Goya took into account the number of hands he had painted!

So, like painters, photographers paid particular attention to faces, eyes, and hands, which suited their models' tastes, since they too had been brought up in the pictorial tradition. One of the most frequent poses is a half-length seated figure with bare (cat. 1), bejewelled (cat. 3) or gloved hands, which were either folded or resting on the model's knees. Commercial studios had a range of props, balustrades, columns, and occasional tables to help the models remain perfectly still during a long pose. As the camera exposure time shortened, these objects lost their initial function and served to vary the attitudes taken for the portrait. In his studio in the Boulevard des Italiens, Eugène Disdéri, the inventor of *carte-de-visite* portraits, employed a whole range of objects from which his customers could choose to improve their bearing and provide a social context. The most popular prop was a book. It was small but brought cultural endorsement to the person holding it, usually when closed and ignored. A small piece of furniture was therefore a handy place to place a book or a pile of books, which the model appropriated by laying a hand or leaning an elbow on them. The many possible combinations never quite dispel the stereotyped look of these pictures (cats. 6 and 7). The artificial staging is usually obvious, belying the advice given by the same Disdéri in *Renseignements photographiques indispensables à tous* (1855): "The model must take a natural, comfortable pose, forget that he is in front of the camera … and be able to move his arms."

Yet some professional photographers very quickly found ways of getting round the conventional models, as is shown by the quadruple daguerreotype portrait of a father and his three daughters taken by Désiré François-Millet (cat. 2), in which the figures seem to have followed their instincts in the way they placed their hands. To express the "intimate likeness" of the model, an objective that Nadar (Gaspar-Félix Tournachon) set himself (cats. 9–11), and which David Octavius Hill (cat. 8) could have made his own, the presence of a hand is a

precious aid because it is the most individual part of the body after the face. Goethe records that his friend Lavater, the author of *L'Art de connaître les hommes par la physionomie* (1775–78), "looked at the hands not the face; and he saw extraordinary subtleties in them." In the portrait of the actress Ellen Terry when she was still a teenager, taken by the British photographer Julia Margaret Cameron, the girl's hand with a ring on one finger, her wrist encircled by a bracelet, and the fingers clasping a pearl necklace around her neck, say as much as her profile and lowered eyes (cat. 15). The intimacy between the photographer and her model is revealed by the close framing, in which the hands and face compete for the space, as in the many portraits by Edward Steichen (cat. 12). When he started to photograph Georgia O'Keeffe, Alfred Stieglitz was first interested in her hands, and even if to a lesser degree than in the nude portraits of his partner, these images reveal the intimate relation between them (cat. 13). In Frederick Evans's portrait of the illustrator Aubrey Beardsley (cat. 17), and even more so in Laure Albin-Guillot's one of the sculptor François Pompon (cat. 18) the model's face is almost entirely overshadowed by his hand.

Portraits of Hands

The nineteenth century, which presided over the birth of photography, also saw the advent of an aesthetic of fragments, in sculpture even more than in painting, as was shown by the exhibition 'Le Corps en morceaux' (The Dislocated Body), held at the Musée d'Orsay in 1989. In the field of photography, synecdoche—the part taken for the whole—functions in a peculiar way. Whereas painters and sculptors produced fragments directly—a head, a foot, or a hand—photographers would create a fragment by isolating it from the whole to which it belonged, by means of framing or lighting. Appearing at an early stage in photography,

these "portraits of hands" were primarily educational, which in no way detracts from the aesthetic quality of the prints. When Adolphe Bilordeaux photographed plaster casts of hands (cat. 5), photography was a brand-new discipline in the teaching of fine arts. Others, such as Jean-Louis Igout, used live models to create a sort of alphabet of body parts for the use of art students (cat. 4).

This initial educational function was far from Auguste Vacquerie's mind when he photographed the hands of Victor Hugo, his wife Adèle (cat. 14), or his son François-Victor. He envisaged the poet's hand placed in a horizontal position "seeming to grasp something in the clouds" opposite the poem *Ibo* in the collection of poetry *Contemplations* dedicated to Hugo's wife. Whereas Bilordeaux's plaster hand (cat. 5) looks as alive as a flesh-and-blood hand, to the painter Jules Laurens (1825–1901) one of the two photographs of Adèle Hugo's hand suggested "Carrara marble on black velvet" (*La Légende des ateliers*, 1901). The print in the Musée d'Orsay (cat. 14) has fetishist overtones, as the bracelet is believed to contain locks of hair from members of the family.

In 1861 Nadar sent a photograph of an open palm entitled *Hand of the banker Mr D., (chirographic study), taken in one hour with electric lighting* to the fourth exhibition held by the Société Française de Photographie. The only one of its kind in the work of the photographer, this image (cat. 16) is intriguing at first, although a little less so when we know that Nadar owned a book by Adolphe Desbarolles entitled *Mystères de la main: révélations complètes,* illustrated with plates composed in a similar way. Sylvie Aubenas, who refers to this in the catalogue of the exhibition *Nadar les années créatrices* (1994), suggests that the banker "Mr D." could well be Benjamin Delessert, a financier, photographer, and a member of the Société Française de Photographie.

The clasped hands photographed by Bronia Wistreich-Weill (cat. 19) make us think of the hands assembled by Rodin, in the *Secret* (1909) and more particularly the *Cathedral* (1908), even though the photographer used hands belonging to the same person, whereas the sculptor put two right hands together.

Hands have been a source of inspiration for many writers as well as painters, sculptors, and photographers. *La Main enchantée* (*The Enchanted Hand*) by Gérard de Nerval, and *La Main d'écorché* (*The Flayed Hand*) by Guy de Maupassant, function in an anguished register that was taken to the extreme by Maurice Renard in *Les Mains d'Orlac* (*The Hands of Orlac*). The cinema seized upon the subject, too, using original scenarios or adaptations of literary texts: Maurice Renard's novel was made into a film by Robert Wiene in 1924; Gérard de Nerval's work inspired the film *La main du Diable* (entitled *The Devil's Hand* in the United Kingdom, and *Carnival of Sinners* in the United States) by Maurice Tourneur in 1942.

Serving the Image of the Great Man

When Victor Hugo was exiled and settled in Jersey, he was determined not be forgotten. He wasted no time setting up a photographic studio with his sons and Auguste Vacquerie, and posed for numerous portraits for his readers and political friends. Although his visual references are pictorial, they belong less to middle-class portraits than to history painting and its heroes. Admittedly, he was not the first to take an interest in his image and its diffusion, and although his most illustrious predecessors did not have the benefit of photography, similarities and parallels can be seen in the image-building strategy Hugo used and the role played by the position of his hands. In this respect, the typology of portraits of

Napoleon I is particularly interesting. Bonaparte was first of all general and hero of the battles that helped forge his glory, a leader of men shown on horseback, his arm outstretched in a sweeping, galvanising gesture, urging his troops to cross the Arcole bridge or the Great Saint Bernard pass. When Napoleon became first consul, and then emperor, he wanted to project the image of a moderate sovereign, anxious to attenuate the consequences of the revolutionary wars, and to break away from the dramatic gestures associated with rostrums of the Revolution. He then posed in the attitude for which he is now famous, with one hand thrust into his waistcoat. Borrowed from antique orators who kept one arm under their togas as an indication of modesty and moderation—it was considered unseemly to bare an arm during a speech—this gesture became part of treatises of rhetoric, good conduct, and theatrical action, but also of portrait painting, denoting *sophrosyne*, or thoughtful self-control. The few portraits made of Napoleon after his abdication show him as a private individual, with his hands in his pockets! However, to return to Victor Hugo, it was not the successive phases of his life and career that determined his attitude towards the camera, but the desire to emphasise a facet of his personality. Folded arms (cat. 20) give him a determined look which befits a man who fought during the revolutionary uprisings of 1848. A hand on the temple suffices to conjure up the thinker and the poet; an impression strengthened by the book that Victor Hugo is holding in his hands (cat. 21). Here the book is open, and the poet is taking no notice of the camera but seems to be absorbed in his reading; in this case the book is not a prop in a staged scene, as it was with Disdéri, but helps to create a context. Lastly, when Hugo poses with his hand thrust into the front of his jacket (cat. 23), with a dreamy look, he recalls his status as an exile and makes sure that posterity would never forget it. As for Auguste Vacquerie, he was clearly strongly influenced by the sessions he took part in and indulged in a degree of mimicry when it was his turn to stand in front of the camera, on his own, or standing beside the great man (cat. 22).

They Almost Speak

"Hands are capable of countless movements, almost as many as there are words. They speak, or very nearly. They ask and promise, summon and dismiss, they threaten and beg. They express horror, fear, joy, sadness, hesitation, avowal, repentance, moderation, plenty, number and tense. Are they not capable of exciting and calming, imploring, approving, admiring, making a show of modesty?" Thus wrote Quintilian in his *Institutio oratoria* (1st century AD). The meaning of hand movements has given rise to a whole series of symbols. These range from the "hand of justice" symbolising the absolute judicial power accorded to the kings of France during the coronation ceremony (from which moment the king's hand assumed the miraculous divine power of healing scrofula), to the more recent open hand gesture of the 1980s used as an emblem by supporters of the antiracist movement "Touche pas à mon pote" ("Hands off my mate!"). Many attempts have been made to codify these symbols, as is shown in the numerous treatises on chirology, mimography, Buddhist mudrā, and sign language.

Most of the images we see are easy to decipher. An outstretched hand, palm upwards, clearly indicates begging (cat. 28), whereas hands pressed together like those of young Florence Anson in a portrait by Julia Margaret Cameron are associated with prayer (cat. 24). To illustrate the passage of the *Idylls of the King* by Alfred, Lord Tennyson in which Vivien tries to hold Merlin the enchanter in her thrall, all the photographer needs to do is get the young woman (Agnes Mangles) to hold up a finger to convey the power she wields (cat. 29). In quite a different register, Nadar also shows power through the hand of the doctor who, to display a physiological anomaly, both exhibits and holds, in a clinical gesture, the genitals of the hermaphrodite that he photographed on the request of Dr Armand Trousseau (cat. 32).

The author of the reportage made in the Jewish community of Warsaw about 1919 does not seem to have influenced the poses of the people he photographed. Their attitudes are no less significant. The intertwined hands of a mother and her daughter (cat. 26) can be seen as a gesture of protection, whereas the vacant-looking young man's gesture of placing his hand over his mouth (cat. 27) reveals the depth of his distress. Some hand-postures, however, are more difficult to interpret, like that of the boy posing for Wilhelm von Gloeden with his hand pressed against his chest (cat. 25); other gestures can be understood in various ways, depending on the context. The bound wrists of the naked woman offered by Charles-François Jeandel (cat. 30) have an obvious erotic connotation; while the model in an almost identical posing for Lewis Carroll conjures up the mythical figure of Andromeda chained to the rock before Perseus comes to deliver her (cat. 31). Actors, such as Elisabeth Terry who played a part in this scene orchestrated by Lewis Carroll, used hand movements as an essential part of acting. Others who rely heavily on hand movements are mime artists, such as Jean Charles Deburau (cat. 40) and Paul Legrand (cat. 41), and also dancers. Alfred de Meyer's photographs of performances of Debussy's *Prélude à l'après-midi d'un faune* show how Nijinsky (cat. 36) and the dancers with him (cat. 35 and 37) used the expressive possibilities of their hands to the utmost. When Marius de Zayas made a caricature of the dancer Ruth Saint Denis (cat 38), who was also photographed by Alfred de Meyer (cat. 39), he focused on her hand, which makes a strange angle with her wrist, snake-like, the two large rings on her fingers sug-gesting its eyes. As well as the dance of the veils for which she was famed, Loïe Fuller performed *The Dance of the Hands*. Influenced by the theatre, oriental dance, and the work of the sculptor Auguste Rodin, Fuller invented a new body language in this dance, giving her hands the task of expressing the emotions conveyed by the music. "The mind expresses itself through the body," she explained, "whereas a hand separated from the

body can express its glory, its sorrow, its pain, with as much perfection as the human form as a whole." In the photograph (cat. 34) used to illustrate the programme of the Châtelet Municipal theatre in May 1914, Fuller is raising both hands as an offering, palms open to the sky.

"God in Five Persons"

"I do not know," wrote Henri Focillon in *Éloge de la main,* "whether there is a break between the manual order and the mechanical order; I am not too sure, but the tool at the end of his arm does not contradict the man, it is not an iron hook screwed into a stump; between them, there is the god in five persons which runs through the entire scale of greatness, the hand that built cathedrals, the hand that illuminated manuscripts."

As special extensions of the brain, hands allow man to give concrete form to his thought through drawing and writing. Rock paintings, and positive or negative handprints on cave walls, are the first evidence we have of the use of hands as an instrument of artistic creation.

In his self-portrait (cat. 47), Edward Steichen's face barely emerges from the shadows, but his right hand holding the brush is in the centre of the composition in a position very similar to that used by George Seeley for the photograph of an unidentified woman, invested with the mission of symbolising *The Artist* (cat. 45). If artists give such importance to the hands of musicians (cats. 44 and 46) and sculptors (cats. 48 and 49), is it perhaps to pay homage to their own hands, without which their creations would not

have been possible? In his *Écrits et propos sur l'art* gathered and published by Dominique Fourcade in 1972, Henri Matisse dwelt several times on the complex relationship between the artist's will and the action of his hand: "If I trust my hand when it draws, it is because when I was learning to use it I strove never to let it get the better of my feelings. I feel it very clearly, when it paraphrases there is disagreement between us— between my hand and something in me which seems to be submitted to it."

"Their hands resemble their tools / Their tools resemble their hands," wrote the artist Fernand Léger in *Les Mains des constructeurs,* a text he dedicated to the memory of the Russian poet Vladimir Mayakovsky. Indivisible from the creative act, the hand is also the workman's tool. For the songwriter Gaston Montéhus, the loafers, swindlers and tricksters (by which he meant the nobles, priests, and politicians) have "white hands", whereas the workers' hands "are not white / They are bruised and crushed". They are the same hands that grasp, hold, and wield farm tools in Constant Famin's photographs of peasants at work (cat. 50), and in Paul Strand's portrait of a man hoeing in Mexico (cat. 53); in Henri Rivière's shots of hands working pulleys and stage flats in the wings of the Chat noir cabaret venue (cat. 51). Charles Lhermitte, the son of the painter Léon Lhermitte (whose large painting, *La Paye des Moissonneurs* [*Paying the Harvesters*] is in the Musée d'Orsay), was interested in the traditional trades and crafts in Brittany, especially the work of the lace-makers (cat. 54). Lewis Hine, an American photographer who produced photo-reportages for social ends, shows young tenement workers making ornaments (cat. 55). The hand is a symbol of progress as well as of work. This is what Alfred Stieglitz meant when he called a photograph of a locomotive in a cloud of smoke the *Hand of Man* (cat. 62). This image never fails to conjure up one of the Lumière brothers' famous early films *L'arrivée d'un train en gare de la Ciotat* (*Train Pulling into Ciotat Station*).

An Eye without a Hand?

"When we will know that the quality of a tone or a value depends not only on the substance they are made of, but also on the manner in which they are laid, then the presence of the god in five persons will become manifest everywhere. Such is the future of the hand, until the day when we will paint by machine or blow-lamp. Then the cruel inertia of the negative will be reached, obtained by an eye without a hand, which offends our friendship by seeking it, a marvel of light, a passive monster. It makes us think of the art of another planet, when music will be the graphics of sound, where thoughts will be exchanged without words, by waves." With this stance Henri Focillon joined a debate that started with photography itself and still lingers a hundred years later: Is photography a purely mechanical activity, or is the artist's role crucial to the success of a print? While this debate was raging, the *Bulletin de la Société française de photographie* recorded in 1855 the quarrel between proponents and opponents of the practice of retouching photographs. Paul Périer declared that "in art, the perfection of the end result is everything; the means are nothing, or at least they fade into insignificance before the goal. … In short, allow us to reach a superior level and completeness with sober retouches. You are free to be proud of a form of fetishism which will often leave you vegetating in the approximate." To which Eugène Durieu retorted: "Good or bad, I think that, from the point of view of the art of photography (the only art in question here), retouching must be condemned."

Usually carried out in such a way as to be imperceptible, retouching is only one of the possibilities of manual intervention available to the artist and some of them leave more visible traces. Thus hand tinting was very soon used on daguerreotypes (cat. 2), by artists employed by the larger photographic studios, or by the photographer himself in the case of smaller establishments; some even entrusted this task to his wife or his daughter. In the album

Souvenirs d'Orient which was bought by the Musée d'Orsay in 1983, James Robertson included a few plates on the costumes and occupations of Constantinople alongside his photographs of the Crimean War and views of Greece, Egypt, and Palestine. Taken between 1853 and 1856, these salted-paper prints were hand-painted by the photographer, who was a deft watercolourist (cat. 56). Robertson coloured the entire surface of the print, a task made easier by the high absorbency of the salted-paper support. With albumen paper prints, which were less absorbent, additives had to be used and so watercolour was reserved for a few areas of the picture, usually the costumes, as in the Japanese scenes recreated in the studio of Robertson's brother-in-law, Felice Beato (cat. 42).

A few decades later, through the voice of René Le Bègue (*Photo-revue*, 6 March 1904), the Pictorialist movement claimed that "the photographer, whose sole aim is to obtain a beautiful image according to the artist's aesthetic, must have the freedom of means to achieve it." The advocates of this international trend wanted to legitimise photography as a means of artistic expression in its own right. They permitted themselves manual interventions at all stages in the creative process. The critic Sadakichi Hartmann, who documented the genesis of several works by Frank Eugene, stated that the photographer frequently reworked his negatives with oil paint, an etching needle, or a pen, traces of which can be seen in the final print, as shown in the hatching visible in *Adam and Eve* (cat. 57). Whatever they did to their negatives, the Pictorialists regarded them as an intermediate step in making the final print. They criticised the modern processes for giving an overly sharp image, and preferred to use pigments, gum bichromate, oil-based inks and oil paint, or even carbon processes. "Operations took a new turn with these processes, because changes made by hand had never been used in such a decisive manner. There was nothing automatic in the production of these images; they were developed under the expert fingers of the artist, whose main

concern was to obtain the right *values*" (Michel Poivert, *Le Pictorialisme en France*, 1992). The addition of pigments to gum-arabic melted with potassium dichromate, which acted as a sensitiser, enabled the photographer to give a wide variety of tints to the contact prints taken from the same negative (cats. 58 and 59).

Appearing in France and England in the 1850s, photomontages or photographic collages brought together items from various sources, which were cut out and assembled to produce a composite image. When a photographer had an ideological reason for retouching his work—like Eugène Appert, whose photomontages made during the Paris Commune were designed to provide damning evidence against the communards—he would try to hide any tell-tale traces of falsification. But when used openly—as was obviously the case in the album put together by Georgiana Berkeley using photographs of her close friends and family (cat. 61), or in the much more violent plates assembled by an unknown hand in Lyons in 1865–70 (cat. 60)—photomontage is undeniably the genre in which the intervention of the artist's hand is the most vigorously asserted.

Entries

1. Anonymous, *Deux jeunes filles les mains croisées* [Two girls with folded hands], ca. 1850. Coloured daguerreotype, 6.7 x 5.7 cm. Gift of the Kodak Pathé Foundation.
PHO 1983 165 376

2. Désiré François-Millet (active in Paris 1850–66), *Un père et ses trois filles* [A Father and his Three Daughters], ca. 1855. Coloured daguerreotype, 15 x 20 cm. Gift of the Kodak Pathé Foundation.
PHO 1997 6 5

3. Anonymous, *Femme aux bagues* [Woman wearing rings], between 1840 and 1850. Daguerreotype, 10 x 7 cm.
PHO 1985 99

4. Igout Jean-Louis (? 1837 – ? after 1881) and Calavas Frères, publishers (active in Paris 1875–1930), *Jeu de mains, étude pour artistes* [Study of hands for artists], ca. 1880. Albumen paper print from a collodion glass negative, 19.4 x 13.8 cm. Gift of Mr Carmelo Carra through the Société des Amis du Musée d'Orsay.
PHO 1992 19 2

5. Adolphe Bilordeaux (? before 1830 – ? after 1870), *Étude de main en plâtre* [Study of a plaster hand], 1864. Albumen paper print from a dry collodion glass negative, 23.3 x 30.5 cm. Loan from the Mobilier National.
DO 1979 84
Produced in the beginning for the artists, these studies were progressively used also when teaching.

The first photograph at the École Nationale des Beaux-Arts was registered on May 1863. The collection of the École Nationale counts today more than 70,000 pieces.

André-Adolphe-Eugène Disdéri (Paris 1819–89)

6. *Madame Georges Petre* [Mrs Georges Petre], 1859. Albumen paper print from a glass negative, 20 x 23.3 cm.
PHO 1995 8 84

7. *Le Comte Potworosky et Monsieur Michel* [Count Potworosky and Mr Michel], 1863. Albumen paper print from a glass negative, 19 x 23.5 cm.
PHO 1995 23 134

8. David Octavius Hill (Perth, Scotland 1802 – Newington Lodge, Edinburgh, Scotland 1870) and Robert Adamson (St Andrews, Scotland 1821–48), *Christopher North (Professor Wilson, dit)* [Christopher North, known as Professor Wilson], 1905. Photomechanical print (half-tone process) from a reprint by James Craig Annan in the 1890s (the original negative was probably taken in 1845), 21.5 x 15.8 cm. Published in *Camera Work* no. 11, July 1905. Gift of Minda de Gunzburg through the Société des Amis du Musée d'Orsay.
PHO 1981 24 25
Christopher North is the pen-name of John Wilson (1785–1854), who was elected to the chair of Moral Philosophy at Edinburgh University in 1820.

Félix Nadar (Gaspar-Félix Tournachon; Paris 1820–1910)

9. *Adam-Salomon,* between 1854 and 1860. Albumen paper print from a collodion glass negative, 20.3 x 17.1 cm.
PHO 1991 2 69
After attending courses by the Bavarian photographer Franz Hanfstaengel (1804–77), Antoine-Samuel Adam-Salomon (1818–81), known mainly for his work as a sculptor, opened his own photography studio on Paris, attracting a clientele similar to Nadar's.

10. *Clémence Basté,* ca. 1855. Salted paper print from a collodion glass negative, 18.4 x 13.5 cm.
PHO 1991 2 41
Clémence Basté had taught Nadar's wife, Ernestine. Ernestine was just eighteen when she married in 1854 and the two women were probably friends. Clémence Basté's pose may have been inspired by Ingres' portraits of women, which Nadar saw at the Universal Exhibition of 1855.

11. *Charles Philipon,* ca. 1855. Salted paper print from a collodion glass negative, 23.9 x 17.9 cm.
PHO 1991 2 56
The founder of several satirical magazines, the most famous of which are *La Caricature*, *Le Charivari*, and *Le Journal pour rire,* Claude Guillaume Charles Philipon (1800–62) used the skills of Honoré Daumier, Gustave Doré, and of course Nadar, whom he hired in 1849.

12. Edward Steichen (Bivange, Luxembourg 1879 – West Redding, Connecticut, United States 1973),

Solitude. Frederick Holland Day, 1906. Photomechanical print (photogravure) from an original negative made in 1900, 12.1 x 16.1 cm. Published in *Camera Work,* Steichen supplement, April 1906. Gift of Minda de Gunzburg through the Société des Amis du Musée d'Orsay.
PHO 1981 25 40
Steichen met the Bostonian publisher and photographer Frederick Holland Day (1864–1933) at *The New School of American Photography* exhibition which Day organised at the Royal Photographic Society buildings in London in October/November 1900. Twenty-one of Steichen's prints were on show in the exhibition.

13. Alfred Stieglitz (Hoboken, United States 1864 – New York, United States 1946), *Georgia O'Keeffe*, 1933. Silver print, 8.8 x 11.2 cm. Gift of the Georgia O'Keeffe Foundation.
PHO 2003 8 21

14. Auguste Vacquerie (Villequier 1819 – Paris 1897), *La main de Mme Victor Hugo avec bracelet* [Mrs Victor Hugo's hand with a bracelet], ca. 1853. Salted paper print, 9.3 x 7.2 cm.
PHO 1986 123 104

15. Julia Margaret Cameron (Calcutta, India 1815 – Kalutara, Sri Lanka 1879), *Ellen Terry, at the age of sixteen,* 1913. Photomechanical print (photogravure) from an original negative made in 1864, diam. 15.8 cm. Published in *Camera Work* n°. 41, January 1913. Gift of Minda de Gunzburg through the Société des Amis du Musée d'Orsay.
PHO 1981 32 5

16. Félix Nadar, *La main du banquier D. (étude chirographique), tirée en une heure à la lumière électrique* [The hand of the banker Mr D. (chirographic study) taken in one hour with electric lighting] 1861. Wet collodion negative, 22 x 11 cm. Loan from the Médiathèque de l'Architecture et du Patrimoine.
DO 1982 65

"From close up it is a strange landscape, with its hills, its great central depression, its narrow river valleys, sometimes crackled with breaks, chains and whorls, sometimes pure and fine like handwriting. One can dream of any figure. I do not know whether the man who reads it has any chance of deciphering an enigma, but I like him to gaze respectfully upon this proud servant." (*Éloge de la main*, Henri Focillon).

17. Frederick Evans (London, England 1853–1943), *L'illustrateur Aubrey Beardsley de profil, le menton dans les mains* [Side view of the illustrator Aubrey Beardsley with his chin in his hands], 1895. Platinum print, 15 x 10 cm.
PHO 1985 351

A close friend of Oscar Wilde, Aubrey Beardsley (1872–98) illustrated the English translation of *Salomé* (1894), a play written in French by the British author.

18. Laure Albin-Guillot (Paris 1879 – Nogent-sur-Marne 1962), *Le sculpteur François Pompon* [The sculptor François Pompon], 1928. Silver print, 22 x 16 cm. Pompon collection, Musée d'Orsay.

François Pompon (1855–1933) worked as an assistant for other sculptors (including Antonin Mercié and Alexandre Falguière) before becoming close to Auguste Rodin; Pompon is known mainly for his animal sculptures.

19. Bronia Wistreich-Weill (active in Vienna, Austria ca. 1925), *Les mains jointes* [Clasped hands] ca. 1925. Gum bichromate print, 23 x 12.9 cm. Gift of Mrs Bronia Wistreich-Weill.
PHO 1989 14 8

20. Charles Hugo (Paris 1826 – Bordeaux 1871), *Victor Hugo debout, les bras croisés, devant la porte de la serre de Marine Terrace, à Jersey* [Victor Hugo standing with folded arms in front of the door to the conservatory at Marine Terrace, Jersey] ca. 1853. Salted paper print, 10 x 7.4 cm.
PHO 1986 123 95

21. Auguste Vacquerie (Villequier 1819 – Paris 1897), *Victor Hugo lisant, devant un mur de pierres* [Victor Hugo reading in front of a stone wall], 1853. Salted paper print, 9.4 x 7.8 cm.
PHO 1986 123 55

Charles Hugo

22. *Victor Hugo et Auguste Vacquerie devant une fenêtre* [Victor Hugo and Auguste Vacquerie in front of a window], 1853. Salted paper print, 9.5 x 7.8 cm.
PHO 1986 123 37

23. *Victor Hugo, la main droite glissée dans l'ouverture de sa veste* [Victor Hugo with his right hand thrust into his jacket], between 1853 and 1855. Salted paper print, 9.8 x 7.7 cm. Gift of Marie-Thérèse and André Jammes.
PHO 1984 86 8

24. Julia Margaret Cameron, *Petite fille en prière* [Little girl praying], 1866. Albumen paper print from a collodion glass negative, 29.5 x 26 cm. Gift of Mrs Ariane Nisberg and Mr Michel Nisberg in memory of Mr Jacques Nisberg (respectively, husband and father). PHO 1988 14

25. Wilhem von Gloeden (Weimar, Germany 1856 – Taormina, Sicily 1931), *Jeune garçon* [Boy] 1900. Silver print, 21.3 x 16.2 cm.
PHO 1986 31

Anonymous photographer working for the American Jewish Joint Distribution Committee (JDC or "Joint", an organisation set up in 1914 to help Jews outside the United States).

26. *Communauté juive à Varsovie: femme et enfant dans une chambre* [Jewish community in Warsaw: woman and child in a bedroom], ca. 1919. Silver print from a gelatine silver bromide negative, 11.8 x 16.3 cm. Gift of Mr Jean Chauvelin through the Société des Amis du Musée d'Orsay.
PHO 1991 23 22
"A hand laid on the shoulder or thigh of another body no longer fully belongs to the body it came from: it and the object that it touches or grasps together form something new, something which no longer belongs to anyone." (*Auguste Rodin*, Rainer Maria Rilke, 1928).

27. *Communauté juive à Varsovie: jeune homme en haillons, debout contre un mur* [Jewish community in Warsaw: young man in rags standing against a wall], ca. 1919. Silver print from a gelatine silver bromide negative, 11.8 x 16.3 cm. Gift of Mr Jean Chauvelin through the Société des Amis du Musée d'Orsay.
PHO 1991 23 36

28. Achille Bonnuit (? 1833 – ? after 1899), *La mendiante* [The beggar woman], ca. 1860. Albumen paper print from a wet collodion glass negative, 14.5 x 10.5 cm.
PHO 1984 73 23
No doubt encouraged by his father-in-law, Jean Charles Gérard Derischweller (1822–after 1884), Achille Bonnuit, a gilder and decorator at the Sèvres porcelain factory, showed a taste for staging which he shared with Charlotte-Elisabeth le Guay (1813–87), herself a painter, who arranged living tableaux in which she took part, here in the role of the beggar woman.

29. Julia Margaret Cameron, *Vivien and Merlin,* 1874. Albumen paper print from a collodion glass negative, 31.2 x 26.5 cm. Illustration for Tennyson's *Idylls of the King and Other Poems*, vol. I, folio 6.
PHO 1980 6

30. Charles-François Jeandel (Limoges, France, 1859-1942), *Femme nue debout trois-quarts dos, attachée par les poignets* [Three-quarter back view of a standing naked women with bound wrists], between 1890 and 1900. Cyanotype, 17 x 12 cm. Gift of the Braunschweig family in memory of the Texbraun gallery.
PHO 1987 18 91

31. Lewis Carroll (Daresbury, England 1832 – Guilford, England 1898), *Elisabeth Terry—called Kate—as "Andromède"*, 1865. Wet collodion negative, 25 x 19.5 cm (modern positive printed from the negative by Patrice Schmidt).
PHO 1988 10 19

32. Félix Nadar, *Hermaphrodite allongé, jambes écartées* [Hermaphrodite reclining with spread legs], 1860. Albumen paper print from a collodion glass negative, 24.5 x 19.5 cm. Gift of the Braunschweig family in memory of the Texbraun gallery.
PHO 1987 17
Nadar took nine photographs of this hermaphrodite. Here the arm of Dr Jules-Germain Maisonneuve, a surgeon specialised in genital disorders, more forcefully affirms the doctor's power than on another print, in which the doctor can be identified.

33. Anonymous, *Dr A. A. Berg*, 1914. Photomechanical print (photogravure) from a caricature by Marius de Zayas, 22.4 x 16.5 cm. Published in *Camera Work* n°. 46, April 1914. Gift of Minda de Gunzburg through the Société des Amis du Musée d'Orsay.
PHO 1981 33 11 4
In this caricature of Dr Berg, a pioneer in digestive surgery, Marius de Zayas draws attention to the hands of the surgeon at work by multiplying them.

34. Harry C. Ellis (Ohio, United States 1857 – ?), *Loïe Fuller dansant. Programme du théâtre municipal du Châtelet* [Loïe Fuller dancing. Programme for the Châtelet Theatre], May 1914. Aristotype, 17.3 x 10.5 cm.
PHO 1984 18 23

Adolphe De Meyer (Paris, France 1868 – Hollywood, California, United States 1946),

35. *Danseuse de profil, tête baissée, mains jointes au-dessus de la tête* [Dancer seen from the side, clasping her hands above her bowed head] plate XXV of the album *L'Après-midi d'un faune*, 1912. Photomechanical print (collotype), 21.4 x 12.2 cm. Gift of Michel de Bry.
PHO 1988 13 25

36. *Nijinsky tenant une grappe de raisins* [Nijinsky holding a bunch of grapes], plate I of the album *L'Après-midi d'un faune*, 1912. Photomechanical print (collotype), 20.7 x 16.1 cm. Gift of Michel de Bry.
PHO 1988 13 1

37. *Nijinsky et six danseuses* [Nijinsky and six dancers], plate XIV of the album *L'Après-midi d'un faune*, 1912. Photomechanical print (collotype), 14.1 x 21.8 cm. Gift of Michel de Bry.
PHO 1988 13 14

38. Anonymous, *Ruth Saint Denis*, 1910. Photomechanical print (photogravure) from a caricature by Marius de Zayas, 22 x 16.6 cm. Published in *Camera Work* n°. 29, January 1910. Gift of Minda de Gunzburg through the Société des Amis du Musée d'Orsay.
PHO 1981 29 8 3

39. Adolphe De Meyer, *La danseuse Ruth Saint Denis* [The dancer Ruth Saint Denis], ca. 1907. Platinum print, 25.1 x 20.1 cm.
PHO 1984 67

40. Félix Nadar and **Adrien Tournachon** (Paris 1825–1903), *Pierrot écoutant* [Pierrot listening], 1854/55. Salted paper print from a collodion glass negative, 28.7 x 21.3 cm. Gift of Marie-Thérèse and André Jammes.
PHO 1991 1 5
Félix Nadar and his younger brother Adrien Tournachon made a series of portraits of the mime artist Jean-Charles Deburau, which won a gold medal at the Universal Exhibition of 1855. The medal was officially presented to Adrien, who held the ownership of the negatives and sold the prints after the two brothers quarrelled.

41. Félix Nadar, *Paul Legrand*, between 1855 and 1859. Salted paper print from a collodion glass negative, 26 x 20.5 cm.
PHO 1991 2 64
Charles-Dominique Martin, called Paul Legrand, was the understudy of Jean-Gaspard-Baptiste Deburau for a time, and replaced him in the role of Pierrot after his death in 1846. Jean-Charles Deburau, the son of Jean-Gaspard-Baptiste, took over the role in 1848.

42. Felice Beato (Venice, Italy 1825 – Rangoon, Burma 1904), *Jonkina danse. Trois danseuses et trois musiciennes* [Jonkina dance. Three dancers and three musicians] ca. 1880. Albumen paper print, coloured, 20.8 x 26.6 cm.
PHO 1992 13 1

43. Pascal Sebah (? 1823 – Istanbul, Turkey 1886), *Groupe de derviches tourneurs* [Group of whirling dervishes], ca. 1870. Albumen paper print from a col-lodion glass negative, 14 x 10 cm. Gift of Mr Serge Gosset.
PHO 1996 5 83
As they dance, the dervishes hold the palm of their right hands skywards to receive the grace of Allah and their left palm to the ground to spread it around.

44. Adolphe De Meyer, *Guitar Player of Seville* [Joueur de guitare à Séville], 1908. Photomechanical print (photogravure) from a platinum print, 20.6 x 15.5 cm. Published in *Camera Work* n°. 24, October 1908. Gift of Minda de Gunzburg through the Société des Amis du Musée d'Orsay.
PHO 1981 27 37

45. George Seeley (Stockbridge, United States 1880–1955), *The Artist*, 1910. Photomechanical print (photogravure) from an original negative, 20 x 15.8 cm. Published in *Camera Work* n°. 29, January 1910. Gift of Minda de Gunzburg through the Société des Amis du Musée d'Orsay.
PHO 1981 29 4

46. Julia Margaret Cameron, *Joseph Joachim (1831–1907), violinist and composer*, 1913. Photomechanical print (photogravure) from an original negative made in 1868, 20.4 x 15.8 cm. Published in *Camera Work* n°. 41, January 1913. Gift of Minda de Gunzburg through the Société des Amis du Musée d'Orsay.
PHO 1981 32 4
"The left hand, which unjustly refers to the bad side of life. ... On a violin, isn't it the left hand which makes the notes, touching the strings directly, while

the right hand, holding the bow, only spreads the melody? Lucky for us that we do not have two right hands." (*L'Éloge de la main,* Henri Focillon).

47. Edward Steichen, *Self-portrait*, 1903. Photomechanical print on Japan paper, from a gum bichromate print, 21.3 x 16.1 cm. Published in *Camera Work* n° 2, April 1903. Gift of Minda de Gunzburg through the Société des Amis du Musée d'Orsay.
PHO 1981 22 11

48. Anonymous, *Aristide Maillol travaillant à l'esquisse de* La Montagne [Aristide Maillol working on a sketch of *The Mountain*], ca. 1936. Silver print, 17.8 x 12.7 cm.
PHO 1986 51 bis
La Montagne (1936) was one of the monumental sculptures by Aristide Maillol (1861–1944) given to the French state by Dina Vierny, the artist's muse and model from 1934 until Maillol's death. André Malraux, the Minister of Culture at the time the gift was made in 1964, decided to put the sculptures in the Carrousel garden in the Tuileries.

49. Edward Steichen, *Henri Matisse travaillant à* La Serpentine [Henri Matisse working on *The Serpentine*], 1913. Photomechanical print (photogravure) from an original negative made in 1909, 22 x 17.4 cm. Published in *Camera Work* n°. 42/43, April–July 1913. Gift of Minda de Gunzburg through the Société des Amis du Musée d'Orsay.
PHO 1981 32 15
"The hand is only an extension of sensibility and intelligence. The suppler it is, the more obedient it is. The servant must not become the mistress" (*Écrits et propos sur l'art*, Henri Matisse).

50. Constant Alexandre Famin (Paris 1827–88), *Paysan fauchant* [Peasant reaping], ca. 1874. Albumen paper print from a collodion glass negative, 16.2 x 12 cm.
PHO 1983 127
Constant Famin made many studies from nature which he officially filed twice (in 1863 and 1874). His images of peasants at work, about which there is still little documentation today, were sold by firms such as Giraudon or Foncelle, to fine arts schools as documentation for teachers.

51. Henri Rivière (Paris 1864 – Sucy-en-Brie 1951), *Le cabaret du Chat noir—Manœuvre des fonds de décor à la lumière* [Le Chat noir cabaret—Moving sets into the light], between 1887 and 1894. Silver print from a collodion glass negative, 12 x 9 cm. Gift of Mrs Guy-Loé and Miss Noufflard.
PHO 1986 122 6
From 1886, Henri Rivière presented his shadow theatre at the Chat noir cabaret opened in 1881 by Rodolphe Salis. Better known for his engravings, he was also a photographer, as evidenced by his views of the Eiffel tower and his reportages in the wings of the cabaret.

52. Félix Nadar, *Kopp,* ca 1855. Salted paper print from a collodion glass negative, 22.5 x 17.6 cm.
PHO 1991 2 36
After earning his living from odd jobs, Kopp embarked on a career as an actor—at the Théâtre de Belleville, the Théâtre Saint-Marcel, then the Théâtre des Variétés—before shooting himself in the head in 1872.

53. Paul Strand (New York, United States 1890 – Orgeval, France 1976), *Man with a Hoe, Los Remedios*; from *The Mexican Portfolio*, plate XI (New York: Da Capo Press, 2nd ed, 1967). Heliogravure from an original made in 1932, 16 x 12.3 cm. Gift of the Kodak Pathé Foundation.
PHO 1983 165 155 11

54. Charles Augustin Lhermitte (Paris 1881–1945), *Concarneau, dentellière sur les rochers* [Concarneau, lacemaker on the rocks], 1911. Aristotype, 17.1 x 12.3 cm. Album Lhermitte n°. 2, folio 8, verso.
PHO 1988 17 65

55. Lewis Hine (Oshkosh, United States 1874 – Hastings-on-Hudson, United States 1940), *Tenement workers making ornaments*, ca. 1910. Silver print, 12.8 x 17.8 cm. Gift of M. Harry Lunn.
PHO 1986 85

56. James Robertson (London, England 1813 – Yokohama, Japan 1888), *Constantinople, femme turque, costume du dehors* [Constantinople, Turkish woman in outdoor costume], plate XXIII of the album *Souvenirs d'Orient*, ca. 1855. Salted paper print, retouched with watercolours, with white highlights, from a collodion glass negative, 19 x 15 cm.
PHO 1983 193 19 B
In his review of the 1855 Universal Exhibition, Ernest Lacan, editor in chief at *La Lumière* (1851–67), the first magazine on photography in France, regretted that Robertson did not present "a few specimens of his types and costumes. There is too much interest in these studies, which are so truthful and instructive,

for us not to reproach the author for have deprived the public, and artists in particular, of them."

57. Frank Eugene (New York, United States 1865 – Munich, Germany 1936), *Adam and Eve*, 1910. Photo-mechanical print (photogravure) from an original negative made in 1898, 17.6 x 12.6 cm. Published in *Camera Work* n°. 30, April 1910. Gift of Minda de Gunzburg through the Société des Amis du Musée d'Orsay.
PHO 1981 29 11

André Hachette (active in France between 1903 and 1945)

58. *Jeune femme en buste, profil perdu, main gauche sur la gorge* [Head and shoulders of a young woman, with her face turned away and her left hand on her throat], ca. 1905. Gum bichromate print, 22 x 16.8 cm.
PHO 1985 313 40

59. *Jeune femme en buste, profil perdu, main gauche sur la gorge* [Head and shoulders of a young woman, with her face turned away and her left hand on her throat], ca. 1905. Gum bichromate print, 22 x 16.8 cm.
PHO 1985 313 39

60. Anonymous, *Obsession 1*, ca. 1870. Photo collage: four prints and added items; size of the sheet: 17.8 x 22 cm.
PHO 2005 8 1
In 2005 the Musée d'Orsay bought twelve collages from a dismantled album which once contained fifty.

These assemblages were thought to have been made in the region around Lyon because one of them contains a scrap of newspaper with a headline containing the word "lyonnais". Dominique de Font-Réaulx, who presented this purchase in the Musée d'Orsay's magazine (n°. 22, spring 2006) suggests that the author or authors many have been inspired by the Dumollard affair, the "maid killer" who was arrested and executed in 1862. She draws a parallel between the executioner's block in the foreground of this plate and one which appears in Paul Delaroche's painting *The Execution of Lady Jane Grey* (London, National Gallery), a painting widely distributed as a photograph and engraving.

61. Georgiana Berkeley (? 1831 – ? 1919), *Éventail avec onze portraits d'hommes, de femmes et d'enfants* [Fan with eleven portraits of men, women and children], folio 20 of the *Album Cavendish,* between 1860 et 1870. Photo collage, albumen prints, and watercolour; size of the sheet: 25.5 x 32 cm.
PHO 1987 36 19

62. Alfred Stieglitz, *The Hand of Man*, 1911. Photomechanical print (photogravure) from an original negative made in 1902, 15.8 x 21.4 cm. Published in *Camera Work* n°. 36, October 1911. Gift of Minda de Gunzburg through the Société des Amis du Musée d'Orsay.
PHO 1981 30 32

Selected Bibliography

AUBENAS, Sylvie, Sylviane de DECKER-HEFTLER, Catherine MATHON, and Hélène PINET. *L'Art du nu au XIXᵉ siècle: le photographe et son modèle*, exhibition catalogue, Bibliothèque Nationale de France, 1997/98. Paris: Hazan/Bibliothèque Nationale de France, 1997.

BRUN, Jean. *La Main*. Paris: Robert Delpire, 1967.

FLECKNER, Uwe. "La Rhétorique de la main cachée. De l'Antiquité au *Napoléon, Premier consul* de Jean-Auguste-Dominique Ingres". *La Revue de l'Art*, no. 130, 2000–4, pp. 27–35.

FOCILLON, Henri. "Éloge de la main", 1934, in *Vie des formes,* followed by "Éloge de la main", Paris: Presses universitaires de France, 1943, 7ᵗʰ edition, 1981.

FONT-RÉAULX, Dominique de "Obsession". *48/14, La revue du Musée d'Orsay*, no. 22, spring 2006.

HEILBRUN, Françoise, Bernard MARBOT, and Philippe NÉAGU. *L'Invention d'un regard (1839–1918)—cent cinquantenaire de la photographie, XIXᵉ siècle,* exhibition catalogue, Musée d'Orsay, 1989. Paris: Réunion des Musées Nationaux, 1989.

HEILBRUN, Françoise, Maria Morris HAMBOURG, Philippe NÉAGU, et al. *Nadar: les années créatrices, 1854–1860*, exhibition catalogue, Musée d'Orsay, 1994; New York, Metropolitan Museum of Art, 1995. Paris: Réunion des Musées Nationaux, 1994.

HEILBRUN, Françoise, and Danièle MOLINARI (dir.). *En collaboration avec le soleil. Victor Hugo, photographies de l'exil*, exhibition catalogue, Musée d'Orsay – Maison de Victor Hugo 1998–1999. Paris: Réunion des Musées Nationaux/Paris Musées/Maison de Victor Hugo, 1998.

MARRAUD, Hélène. *Rodin. La main révèle l'homme*. Paris: Editions du Musée Rodin, 2005.

MATISSSE, Henri. *Écrits et propos sur l'art*. Paris: Hermann, 1991 (first edition in 1972).

PINGEOT, Anne, Antoinette LE NORMAND, et al. *Le Corps en morceaux*, exhibition catalogue, Musée d'Orsay, 1990; Frankfurt, Schirn Kunsthalle, 1990. Paris: Réunion des Musées Nationaux, 1990.

ROUILLÉ, André. *La Photographie en France. Textes & Controverses: une anthologie, 1816–1871*. Paris: Macula, 1989.

ROUILLÉ, André, and Bernard MARBOT. *Le Corps et son image. Photographies du dix-neuvième siècle*, exhibition catalogue, Bibliothèque Nationale de France, 1986, Maison de la Culture de La Rochelle et du Centre Ouest, 1987. Paris: Contrejour, 1986.

Speaking with Hands. Photographs from The Buhl Collection, exhibition catalogue, Solomon R. Guggenheim, New York, 2004; Bilbao, 2005/6. New York: Guggenheim Museum Publications, 2004.

THOMAS, Valérie, Jérôme PERRIN, et al. *Loïe Fuller, danseuse de l'Art nouveau*, exhibition catalogue, Nancy, Musée des Beaux-Arts, 2002. Paris: Réunion des Musées Nationaux, 2002.

VERDAN, Claude. *La Main, cet univers*. Lausanne: Éditions du Verseau et Fondation du Musée de la Main, 1994.

Plates

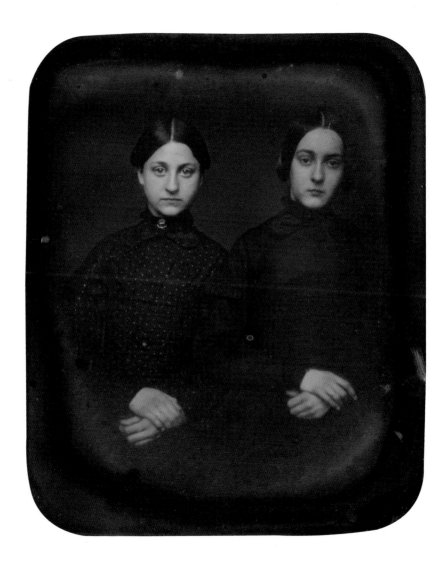

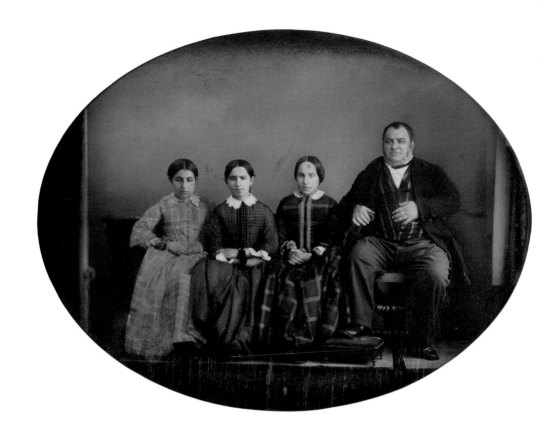

1. Anonyme
Deux jeunes filles les mains croisées
vers 1850

2. Désiré François-Millet
Un père et ses trois filles
vers 1855

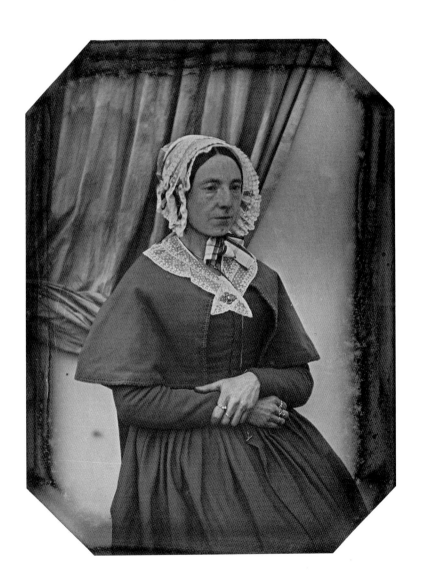

3. Anonyme
Femme aux bagues
1840-1850

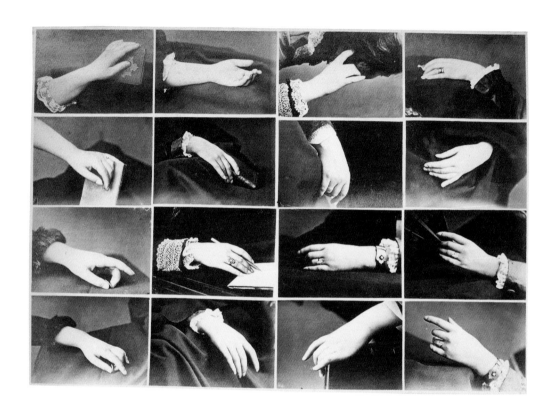

4. Jean-Louis Igout
et **Calavas Frères**
Jeu de mains,
étude pour artistes
vers 1880

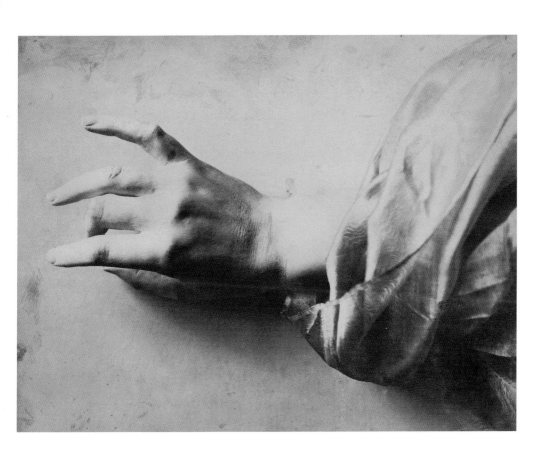

5. Adolphe Bilordeaux
Étude de main en plâtre
1864

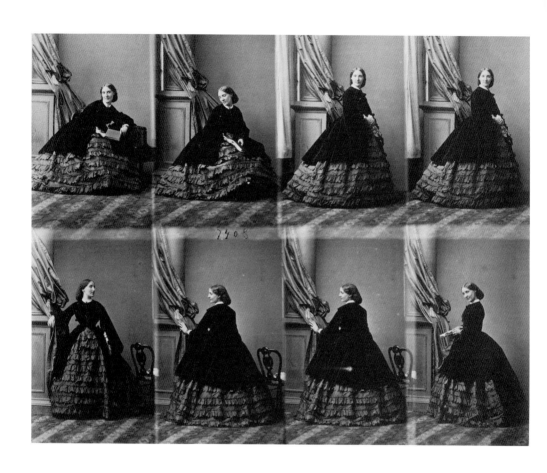

6. André-Adolphe-Eugène Disdéri
Madame Georges Petre
1859

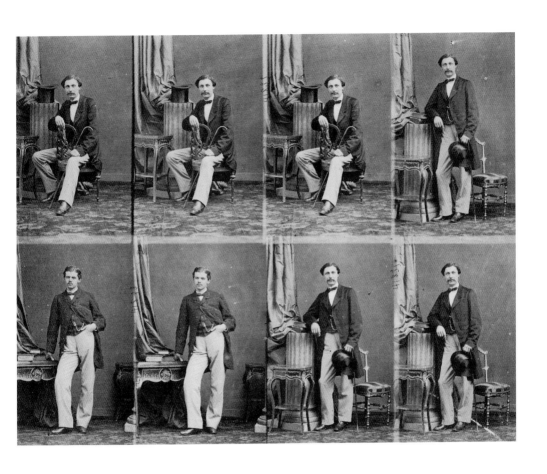

7. André-Adolphe-Eugène Disdéri
Le Comte Potworosky et Monsieur Michel
1863

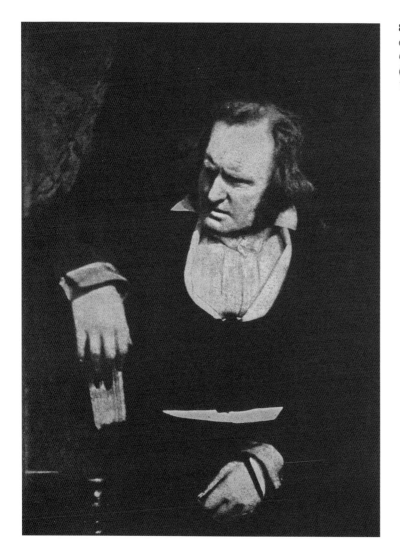

8. David Octavius Hill
et Robert Adamson
*Christopher North
(Professor Wilson, dit)*
1905

9. Félix Nadar
Adam-Salomon
1854-1860

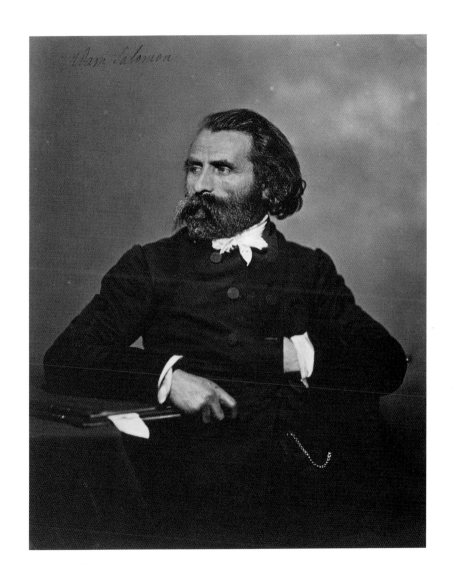

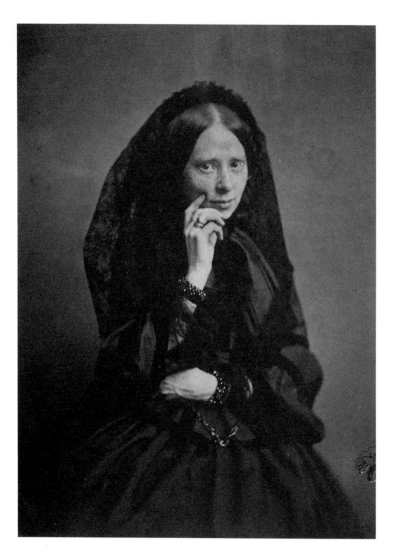

10. Félix Nadar
Clémence Basté
vers 1855

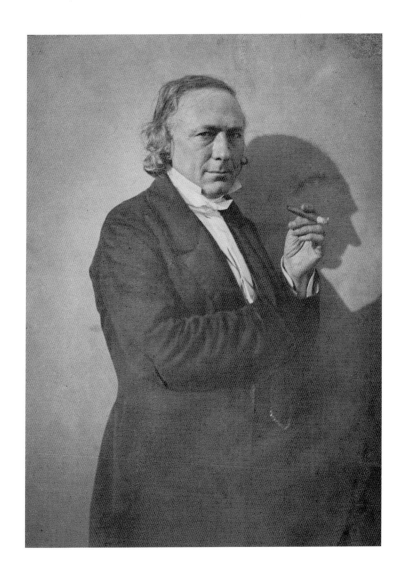

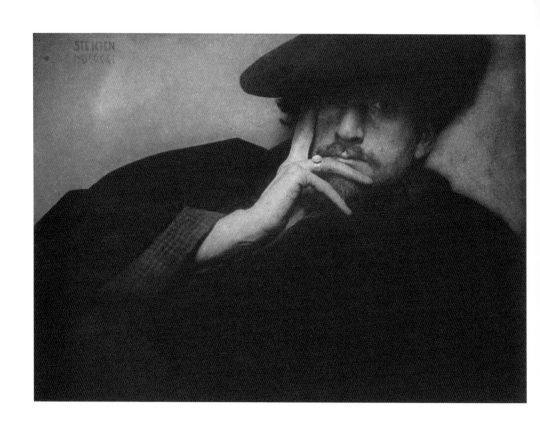

12. Edward Steichen
Solitude. Frederick Holland Day
1906

13. Alfred Stieglitz
Georgia O'Keeffe
1933

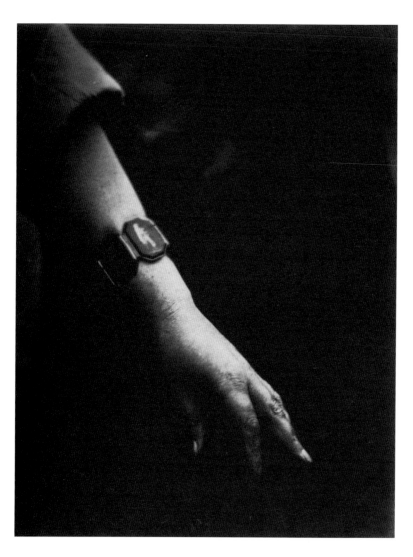

14. Auguste Vacquerie
La Main de M^me Victor Hugo avec bracelet
vers 1853

15. Julia Margaret Cameron
Ellen Terry,
at the age of sixteen
1913

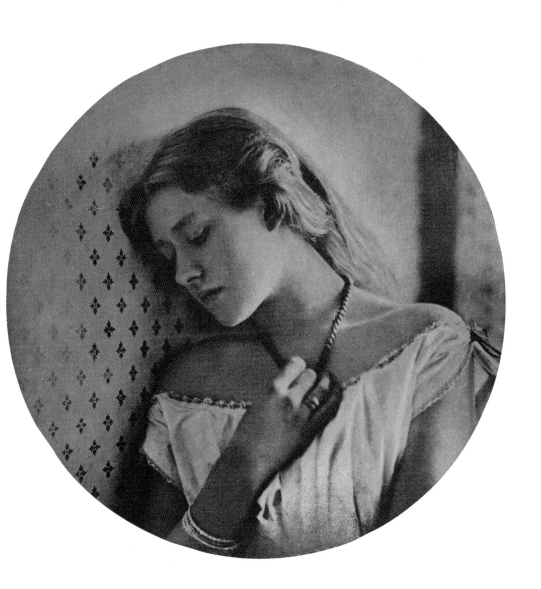

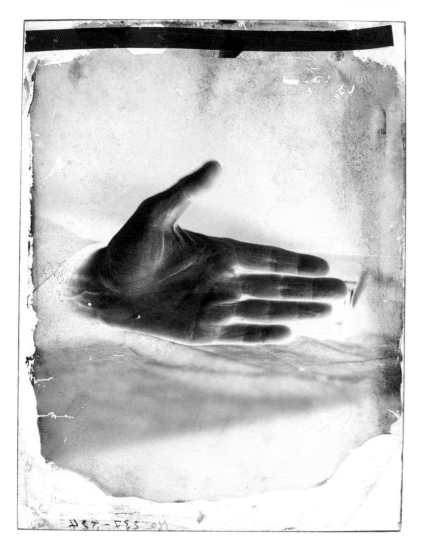

16. Félix Nadar
La Main du banquier D
(étude chirographique)
tirée en une heure
à la lumière électrique
1861

17. Frederick Evans
L'Illustrateur Aubrey
Beardsley de profil,
le menton dans les mains
1895

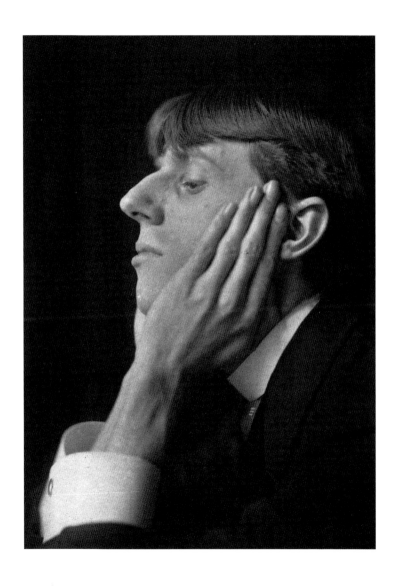

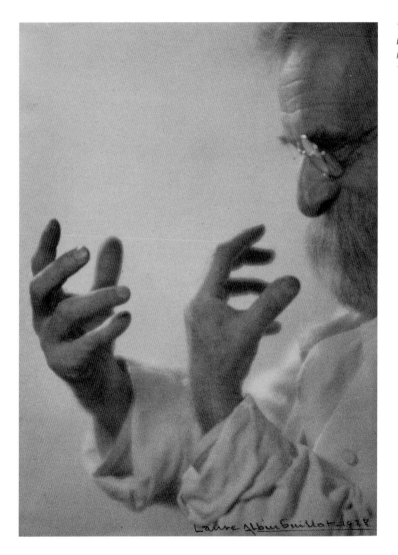

18. Laure Albin-Guillot
Le Sculpteur
François Pompon
1928

19. Bronia Wistreich-Weill
Les Mains jointes
vers 1925

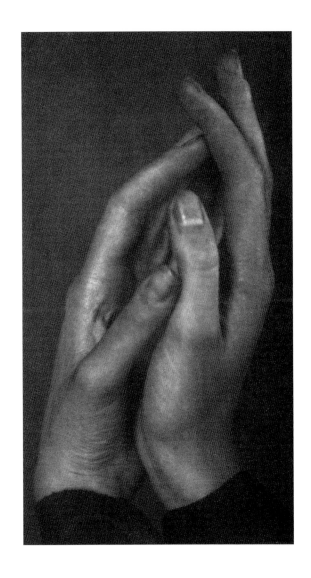

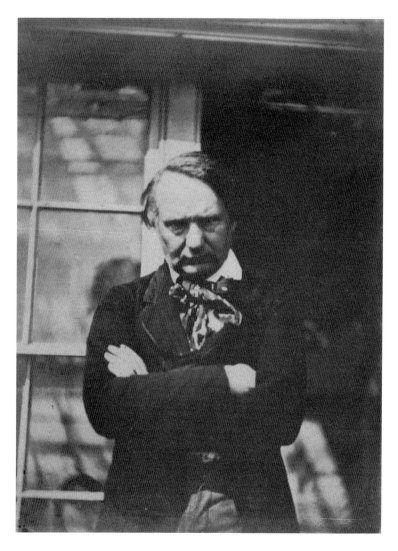

20. Charles Hugo
Victor Hugo debout,
les bras croisés,
devant la porte
de la serre de Marine
Terrace, à Jersey
vers 1853

21. Auguste Vacquerie
Victor Hugo lisant,
devant un mur de pierres
1853

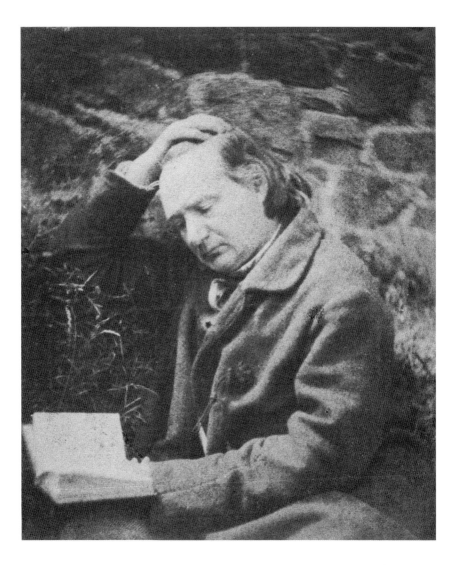

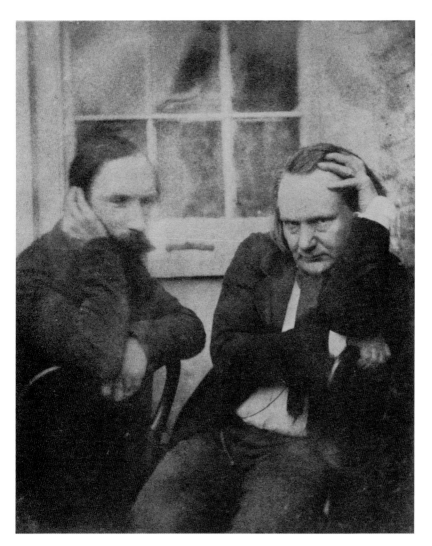

22. Charles Hugo
Victor Hugo et Auguste Vacquerie devant une fenêtre
1853

23. Charles Hugo
*Victor Hugo,
la main droite
glissée dans
l'ouverture
de sa veste*
1853-1855

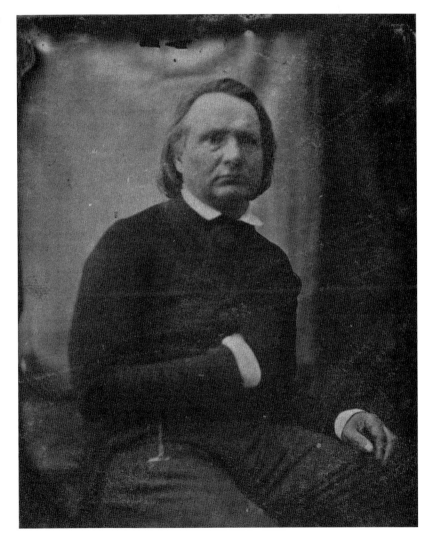

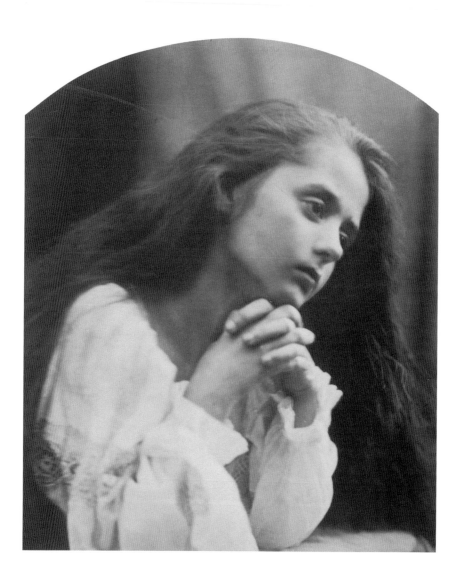

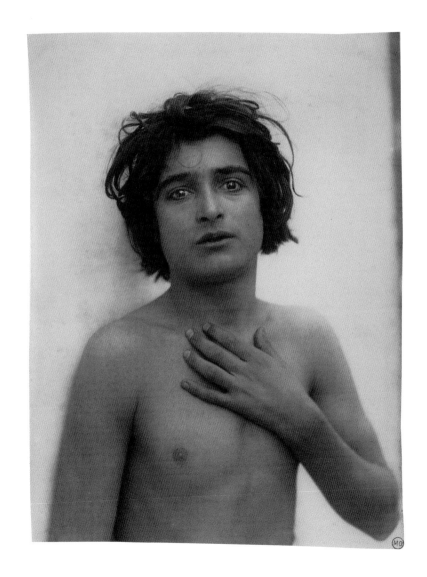

24. Julia Margaret Cameron
Petite fille en prière
1866

25. Wilhem von Gloeden
Jeune garçon
1900

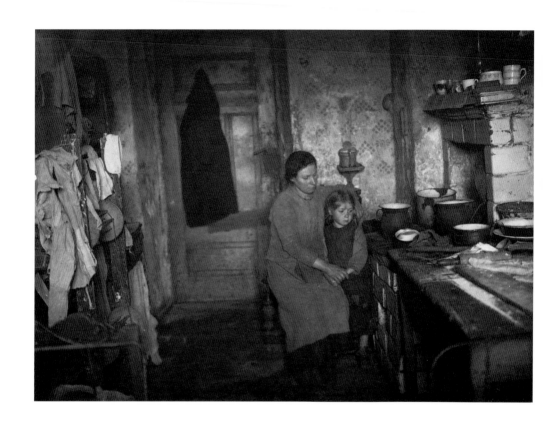

26. Anonyme
Communauté juive à Varsovie :
femme et enfant dans une chambre
vers 1919

27. Anonyme
*Communauté juive à Varsovie :
jeune homme en haillons,
debout contre un mur
vers 1919*

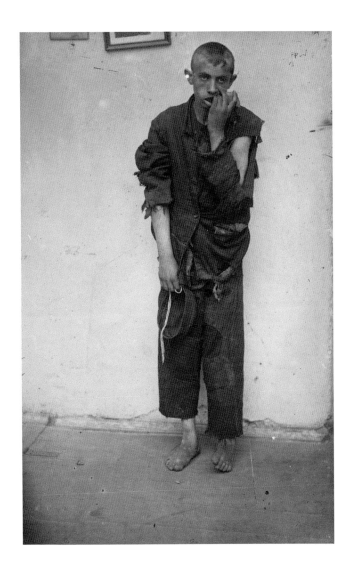

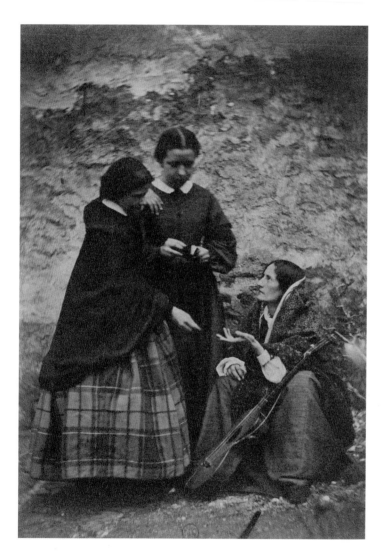

28. Achille Bonnuit
La Mendiante
vers 1860

29. Julia Margaret Cameron
Vivien and Merlin
1874

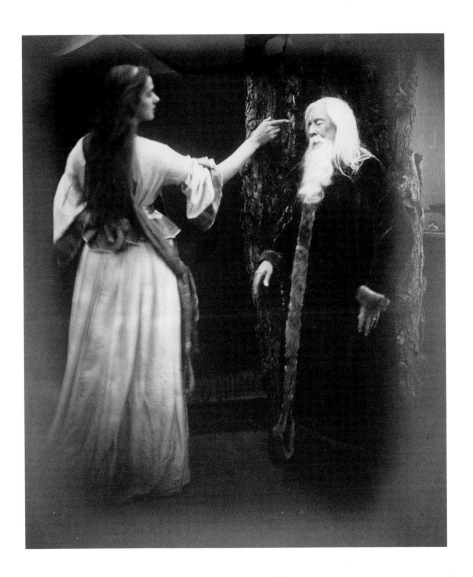

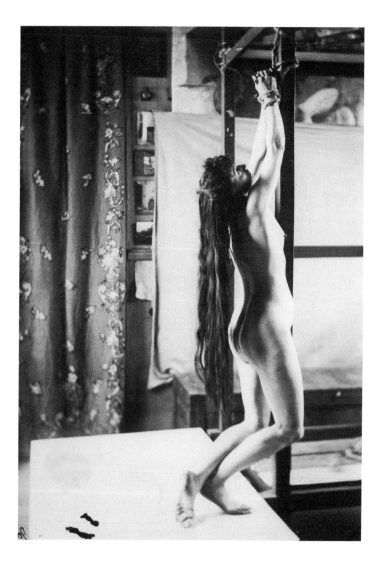

30. Charles-François Jeandel
Femme nue debout
trois-quarts dos,
attachée par les poignets
1890-1900

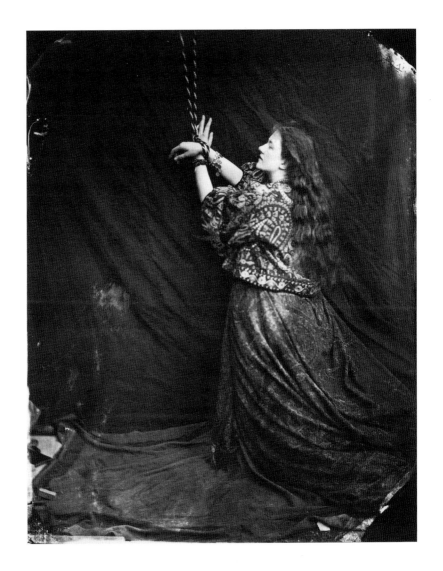

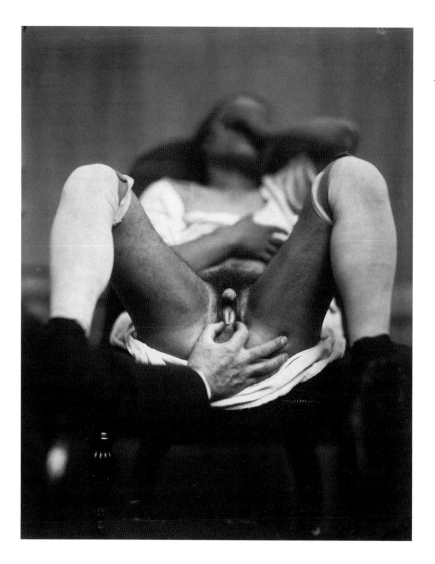

32. Félix Nadar
Hermaphrodite allongé, jambes écartées
1860

33. Anonyme
D' A. A. Berg
d'après une caricature
de Marius de Zayas
1914

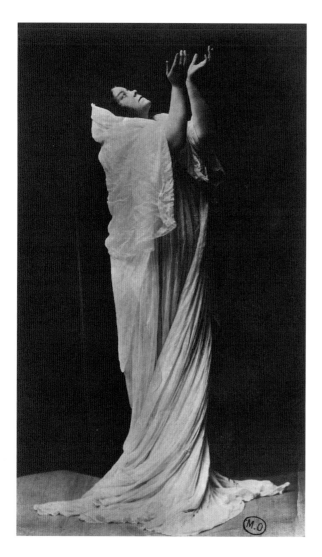

34. Harry C. Ellis
Loïe Fuller dansant.
Programme du théâtre
municipal du Châtelet
1914

35. Adolphe De Meyer
Danseuse de profil,
tête baissée, mains jointes
au-dessus de la tête
1912

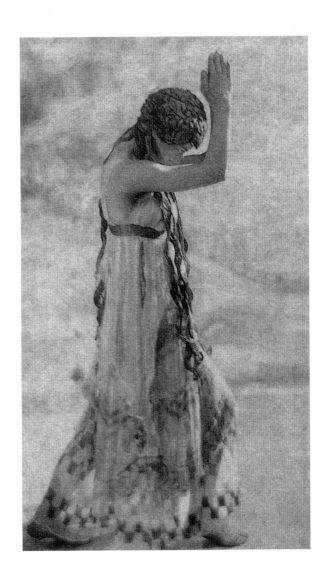

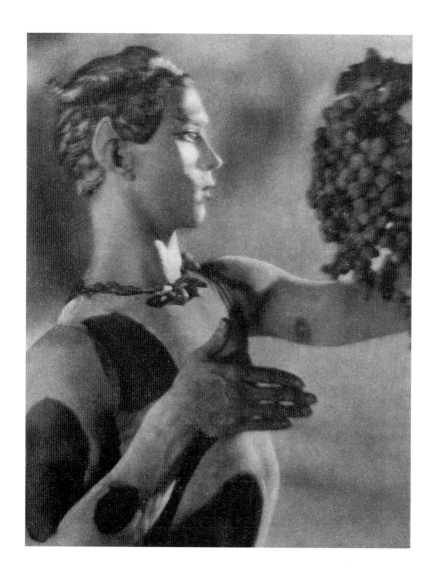

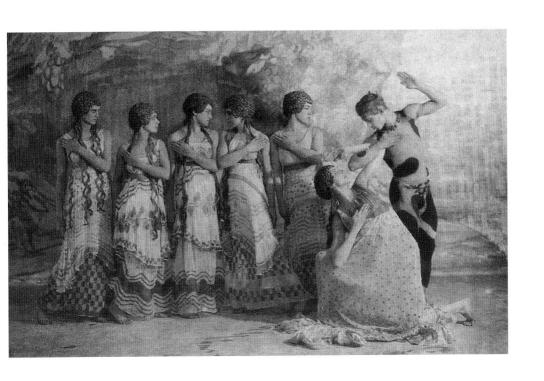

36. Adolphe De Meyer
Nijinsky tenant une grappe de raisins
1912

37. Adolphe De Meyer
Nijinsky et six danseuses
1912

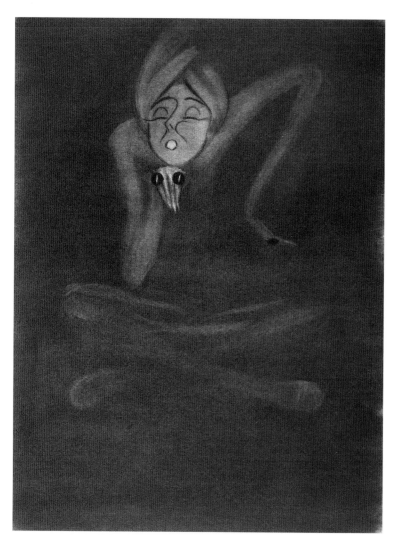

38. Anonyme
Ruth Saint Denis
d'après une caricature
de Marius de Zayas
1910

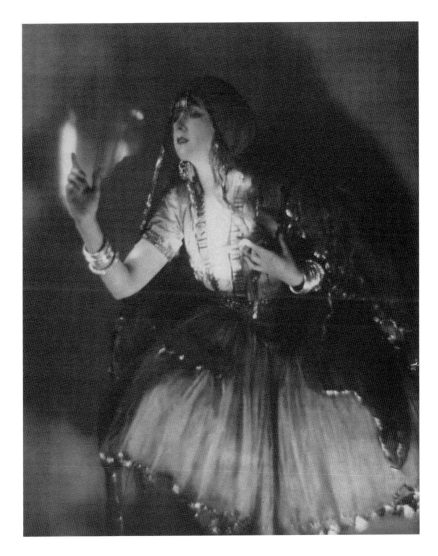

39. Adolphe De Meyer
La Danseuse Ruth Saint Denis
vers 1907

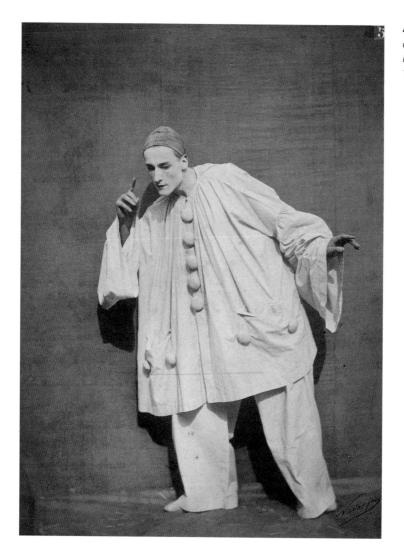

40. Félix Nadar
et **Adrien Tournachon**
Pierrot écoutant
1854-1855

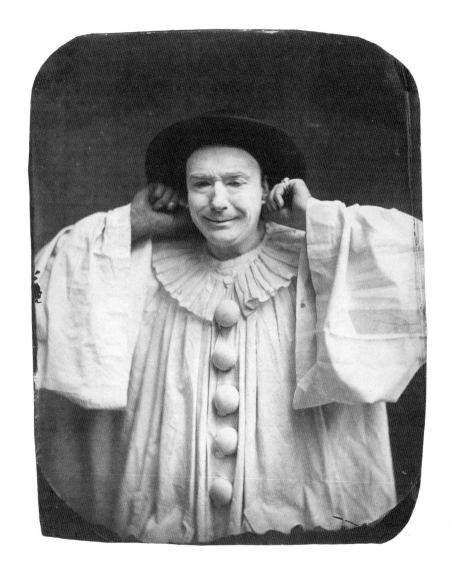

41. Félix Nadar
Paul Legrand
1855-1859

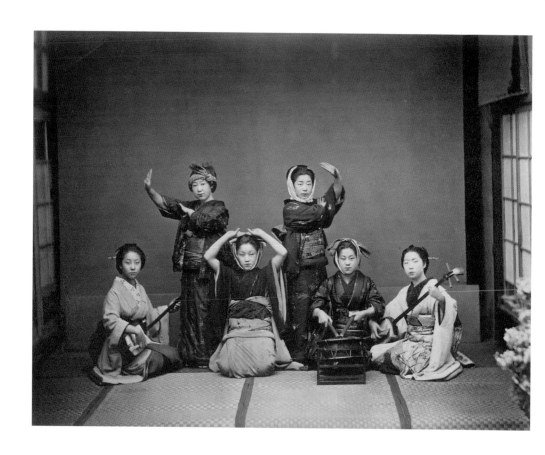

42. Felice Beato
Jonkina danse.
Trois danseuses
et trois musiciennes
vers 1880

43. Pascal Sebah
*Groupe de derviches
tourneurs*
vers 1870

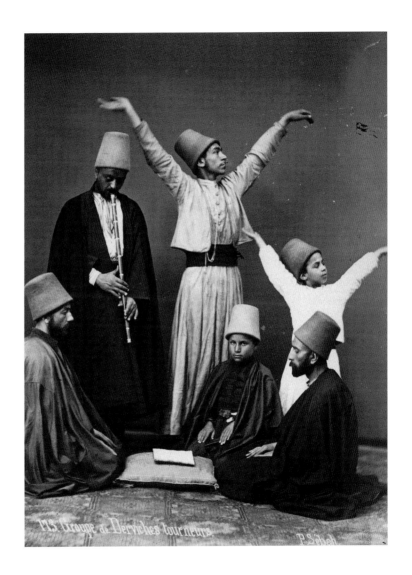

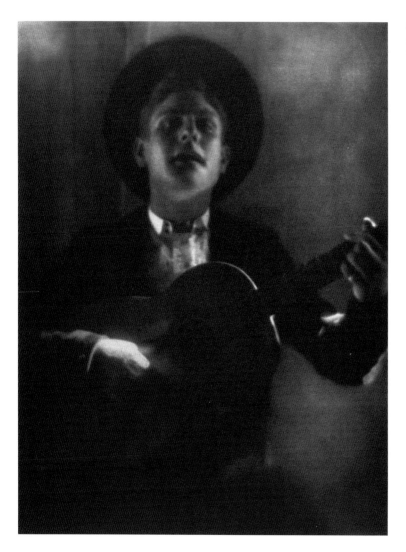

44. Adolphe De Meyer
Guitar Player of Seville
1908

45. George Seeley
The Artist
1910

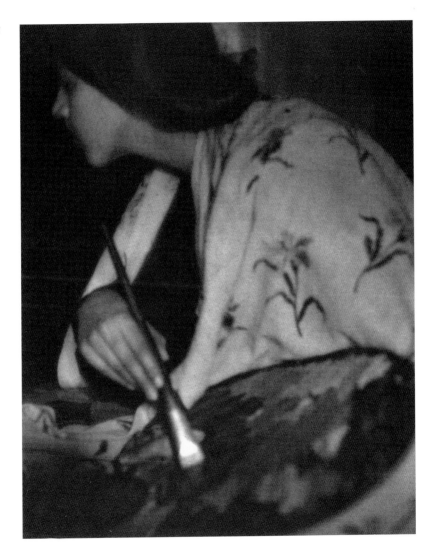

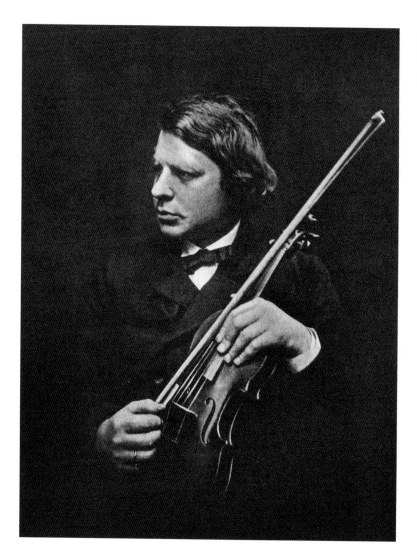

46. Julia Margaret
Cameron
*Joseph Joachim,
violonist and composer*
1913

47. Edward Steichen
Self-portrait
1903

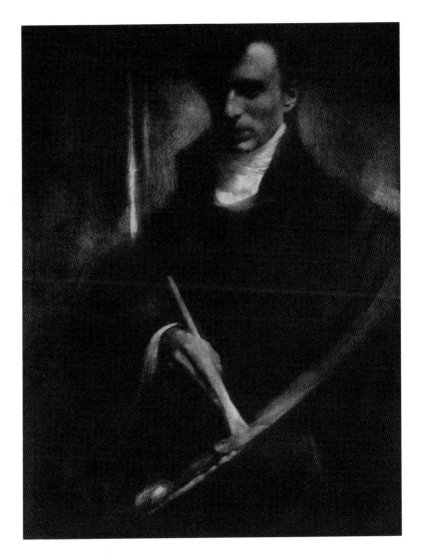

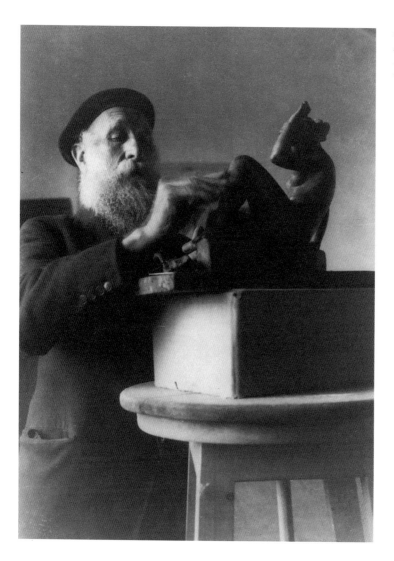

48. Anonyme
*Aristide Maillol travaillant
à l'esquisse de* La Montagne
vers 1936

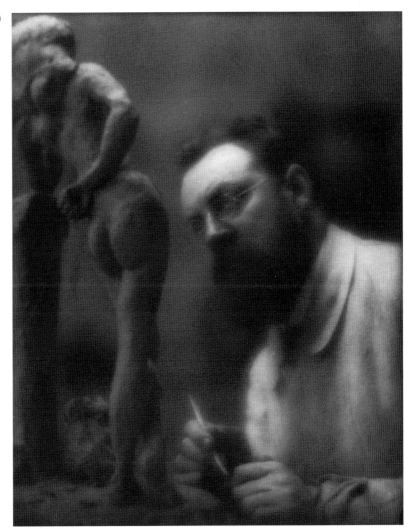

49. Edward Steichen
Henri Matisse
travaillant
à La Serpentine
1913

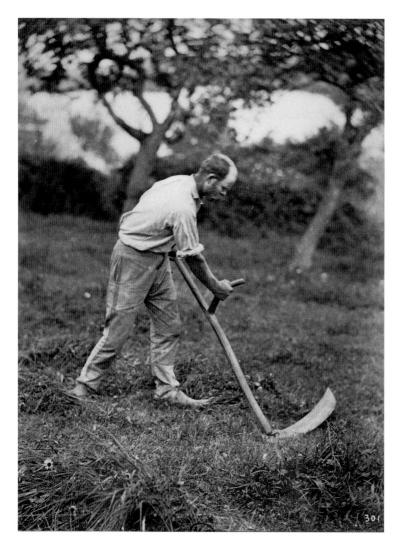

50. Constant
Alexandre Famin
Paysan fauchant
vers 1874

51. Henri Rivière
Le Cabaret du Chat noir
Manœuvre des fonds
de décor à la lumière
1887-1894

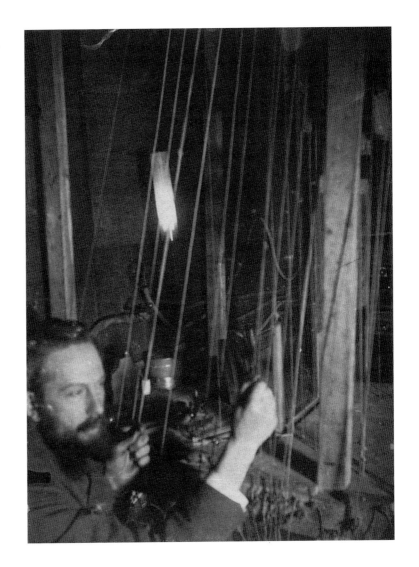

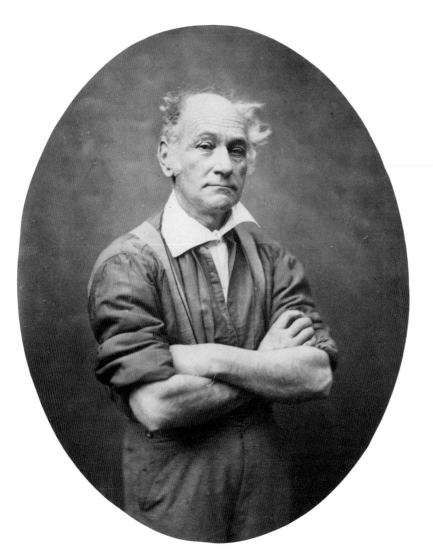

52. Felix Nadar
Kopp
vers 1855

53. Paul Strand
Man with a Hoe,
Los Remedios
1967

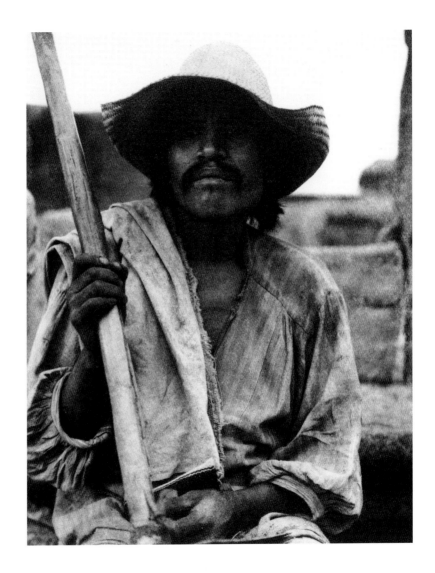

54. Charles Augustin Lhermitte
Concarneau, dentellière sur les rochers
1911

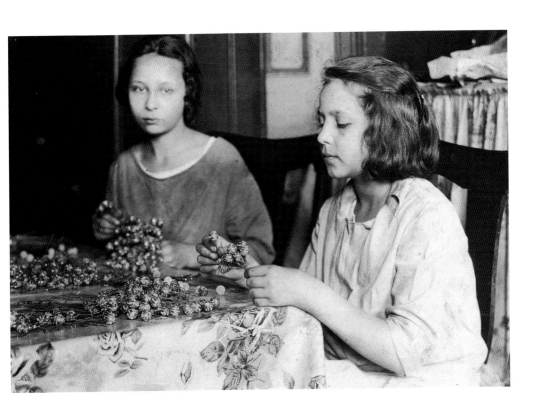

55. Lewis Hine
Tenement workers
making ornaments
vers 1910

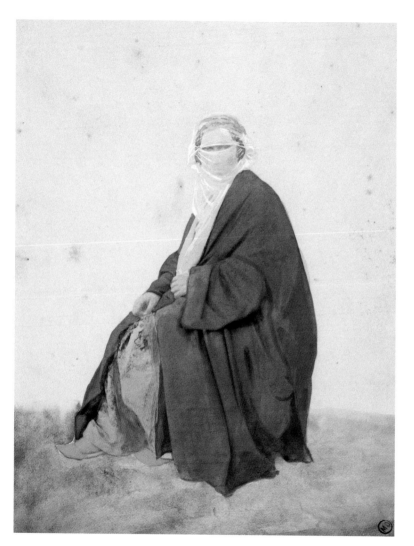

56. James Robertson
Constantinople,
femme turque,
costume du dehors
vers 1855

57. Frank Eugene
Adam and Eve
1910

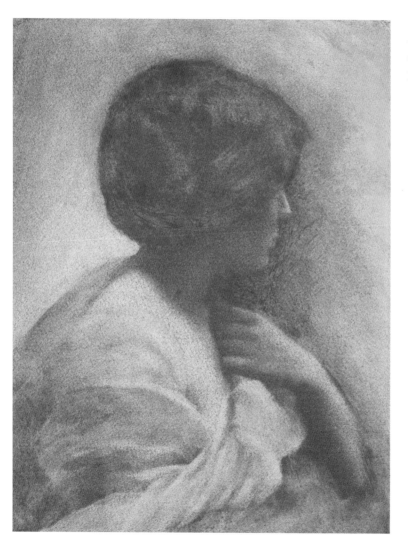

58-59. André Hachette
Jeune femme en buste,
profil perdu, main
gauche sur la gorge
vers 1905

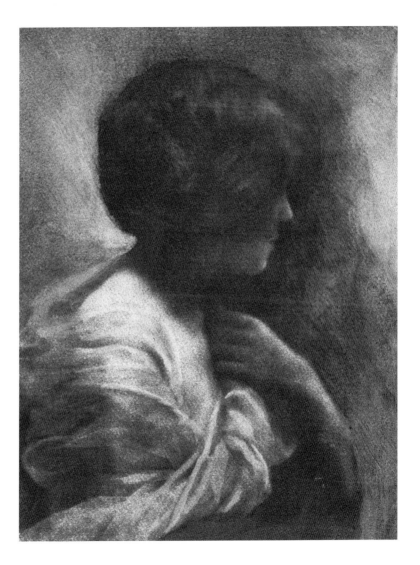

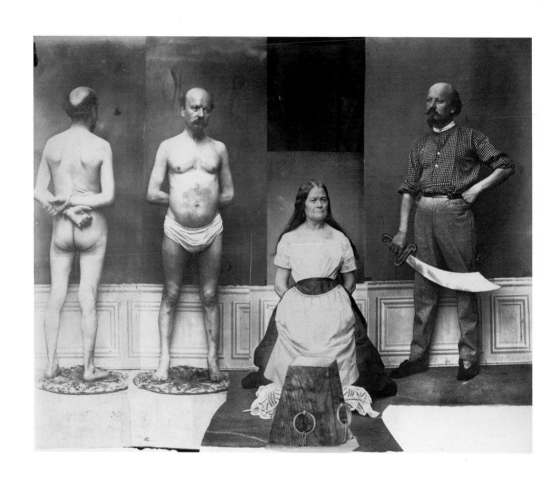

60. Anonyme
Obsession 1
vers 1870

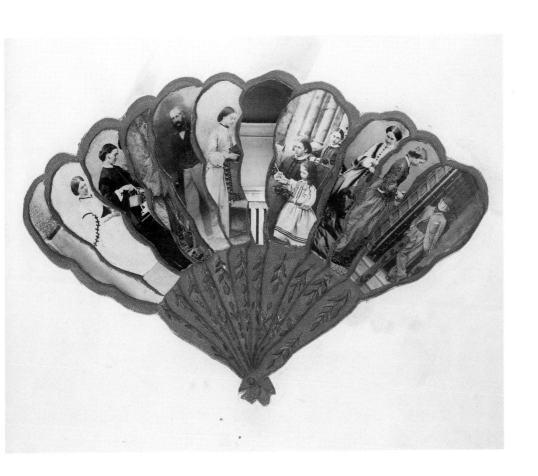

61. Georgiana Berkeley
*Éventail avec onze portraits
d'hommes, de femmes et d'enfants*
1860-1870

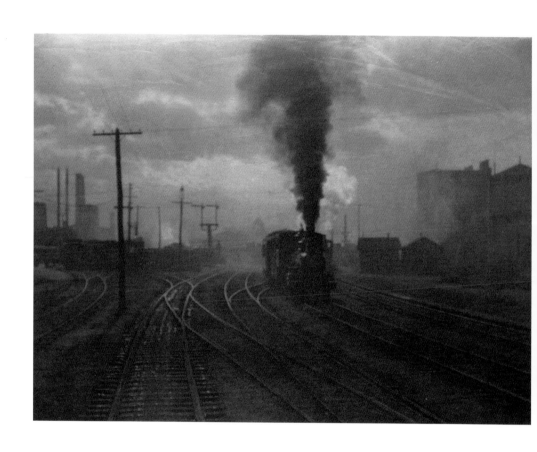

62. Alfred Stieglitz
The Hand of Man
1911